FRIENDS

FIND BEAUTY NOT ONLY IN THE THING
ITSELF BUT IN THE PATTERN OF THE
SHADOWS, THE LIGHT AND DARK WHICH
THAT THING PROVIDES.

—JUNICHIRO TANIZAKI

Face Food: The Visual Creativity of Japanese Bento Boxes
© 2007 by Christopher D Salyers

All photographs © the individual bento artisans.
Photographs on pages 58-63 © Danhiel Baker.

Design & Words: Christopher D Salyers
Editing: Buzz Poole

Typefaces used: McCoy, Hubbubhum, Jaggy Fries, Caslon Old Face

Library of Congress Control #2007937471

Printed and bound by Asia Pacific Offset, China

10 9 8 7 6 5 4 3 2 1 First edition

This edition © 2008
Mark Batty Publisher
36 West 37th Street, Penthouse
New York, NY 10018

www.markbattypublisher.com

ISBN-10: 0-9790486-6-4
ISBN-13: 978-09790486-6-1

Distributed outside North America by:
Thames & Hudson Ltd
181A High Holborn
London WC1V 7QX
United Kingdom
Tel: 00 44 20 7845 5000
Fax: 00 44 20 7845 5055
www.thameshudson.co.uk

FACE FOOD

THE VISUAL CREATIVITY OF JAPANESE

BENTO BOXES

BY CHRISTOPHER D SALYERS

MARK BATTY PUBLISHER
NEW YORK CITY

CHRISTOPHER D SALYERS

ON CHILD-LIKE NAIVETÉ AND

FACE FOOD

y time spent in Tokyo documenting the art of making Japanese character bento boxes – *charaben* – was one of admiration, objective curiosity and of course, dumbstruck awe. The images you see in this book are photographs taken of children's bento boxes, a contemporary twist on an often elaborate culinary tradition dating back to the tail-end of Japan's Kamakura Period (1185 to 1333). Frequently dubbed "too gorgeous to even eat," every character bento is arranged to resemble something other than that plain old sandwich, rice ball or salad. They are borne out of the rampant popularity of movies, television shows and manga pages, sculpted only after years of practice and hours of preparation on the part of the (mostly) mothers assembling this face food. Taking on everything that is bright and pop about post-war Japan, the *charaben* reinvent tradition in a way that is accessible to the entire family, and the world at large.

Some of the parents I spoke to made *charaben* to improve their children's nutritional health (a serious matter in light of Japan becoming increasingly overrun with McDonalds, Starbucks and scores of non-Western fast-food chains). Others had sociological concerns: the *charaben* helped their child become more popular in school, thus improving their social standings and subsequently their ego. While some might try *charaben* for the pure delight of the end product (and with creative results, like pages 66-67), it's the mothers of Japan that I found the most compelling, for the devotion they had to the craft was one inspired by an absolute avidity toward pleasing their children.

When I think of these bento boxes and the children they're made for, I always think of Nico. She lives about an hour's ride from central Tokyo, in an apartment that is all things quaint, cozy and

adorable: children's toys scattered about and manga within arms reach of the kitchen table. Before I could ask her about an antique pair of Raggedy Ann and Andy containers perched on the shelf, she broke in and offered cans of BOSS coffee and the two *charaben* she had made (both characters from popular mangas *Code Geass* and *Home Tutor Hitman Reborn!*, shown on pages 46-49). My immediate reaction was to ask her why she wasn't making *charaben* books of her own, in light of the overwhelming praise she had been receiving and the increased interest some Japanese recipe book publishers had shown in her designs. Instantly her face reddened, her eyes lowered and she threw a palm to the air. "No no," she said. "I have no desire to do that." I could have told her a thousand times, instead of once, that her creations were compelling enough to be regarded with true artistic merit and admired the world over, but I don't think it would have made a dent. The driving force behind these creations is the desire to please children – not art. What sticks with me most about Nico is a detail she shared about her son: growing increasingly opinionated and critical of her talents, he had begun to chastise her for her creations, often complaining of a likeness's minute inaccuracies before, of course, scarfing it all down. And yet Nico, like so many of these mothers, rises early every school day to give her son something wholly unique.

With most of my meetings taking place in the home, the essence of this phenomenon really struck me after encountering an informal club of housewives who meet every month to compare *charaben* designs. This group of women exudes a Martha Stewart-esque appreciation of craft. They all possess their own unique style honed with a singular intent: to garner praise from their child. In a country where hierarchy remains a rigid guideline in schools, social settings and business environments, it became increasingly apparent that not a single one of these mothers met to swap any sort of bragging

rights. On the contrary, these mothers traded secrets to improve each other's craft, to build upon their already exuberant talent and pass this passion off into the stomachs of their little ones.

Tatsuya Kakikawa, aka Takupapa, was the only father I met who made *charaben*. When his wife was hospitalized he had started making them as a way to keep his mind off of her and to build a proper bond with his son. In doing so he fell in love with the technical creativity and seemingly limitless range of the character bento. When I had lunch with Takupapa he brought a Super Mario bento he had made especially for me (pages 18-19); in tow was his little boy, Takkun, wearing matching overalls, a Nintendo DS appropriately glued to his palms, his manic thumbs bouncing off its buttons. Takkun was reaching the age when he really didn't want *charaben* to be made for him anymore; he was becoming a little "too old" to have such a cute lunch before him every day in the school cafeteria. When I asked Takupapa if he would continue to make *charaben* after his son lost all interest, his answer was a prompt and austere "no." Perhaps the true opulence of these bento boxes lies in their medium and their youthfulness – both winsomely finite.

As you flip through the pages of this book, comparing styles and over-analyzing ingredient lists ("How do they do it?" is indeed something I still ask myself), you might notice an innocent joy carved into every face made out of ham, cheese, rice, or seaweed. Though they may not have, as of yet, found their place as an art form, the act of *charaben* alone is one of intense parent-to-child devotion. As a New Yorker accustomed to quick mornings consisting of little more than a coffee and bagel, I acted as the shy observer in the presence of every humble voice that explained to me their regular AM ritual in the kitchen. There is something marvelous and enchanting in *charaben*, something we should all

look to find within ourselves – a convalescence of youth. For all of you whose lunch more closely resembles some pre-packaged, store-bought snack, I offer up these pages as proof that when you show this much dedication to what you or your child eats, the end result will be nothing short of astounding.

THE FACES OF

FACE FOOD

RISA

since when and why did you start making charaben? how often?

Since three years ago. I saw one in a magazine and tried making one, which made my children really happy, so I decided to keep doing it. About 2 or 3 times a week.

who do you make charaben for? how is his/her response?

My children: Very happy. Husband: No response.

describe a typical charaben-making day's schedule.

I look inside the fridge and think of a character I can make with whatever is in there. I start making charaben at 6:00 and finish by 7:30 at the latest.

how do you choose which character to make? which character is your favorite?

I ask my children for any requests. I am currently into characters that could be made with boiled eggs, like pandas.

what do you think draws people to charaben?

Children's smiles when they see charaben. It gives me a great feeling of accomplishment and satisfaction.

what is the moment that makes you love/hate charaben?

Love: I made many new friends. Hate: When I've got a hangover.

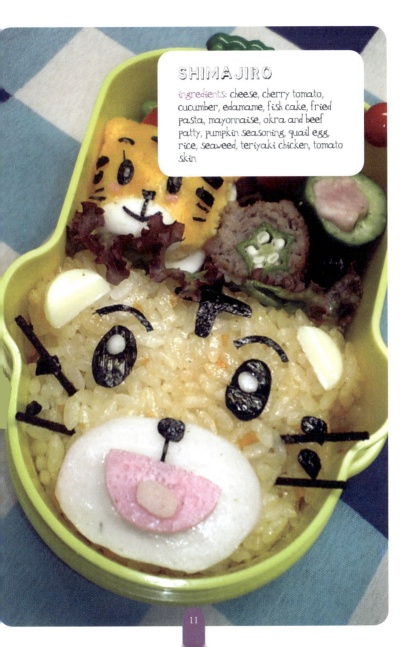

SHIMAJIRO

ingredients: cheese, cherry tomato, cucumber, edamame, fish cake, fried pasta, mayonnaise, okra and beef patty, pumpkin seasoning, quail egg, rice, seaweed, teriyaki chicken, tomato skin

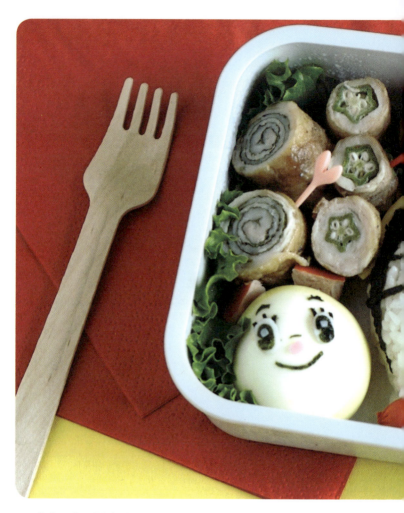

DORAEMON BY RISA

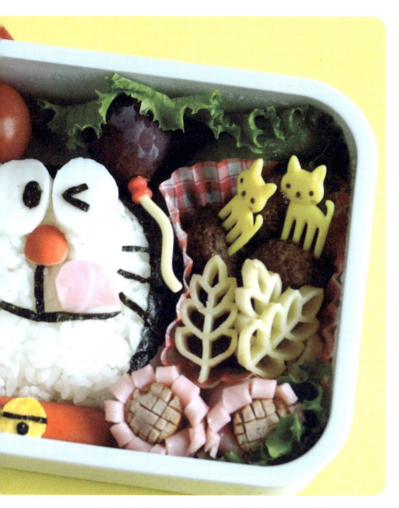

ingredients: chicken curry broth, fish cakes, ham, eggs, red sausage, rice, seaweed

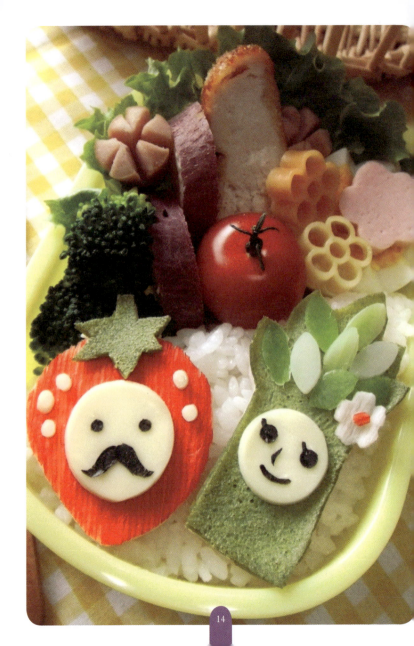

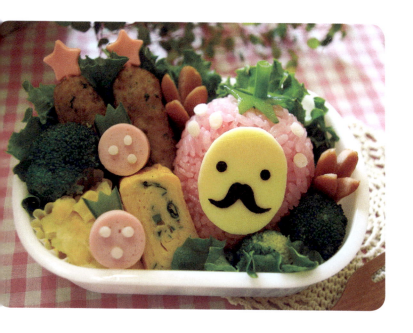

BENRY AND ASKO
FROM TOKYO GAS

ingredients (left): broccoli, cheese, cherry tomato, egg, fried chicken, green beans, ham, imitation crab meat, macaroni, rice, sausage, seaweed, spinach, yam potato

ingredients (top): asparagus, broccoli, cheese, corn, eggs, fish cakes, green beans, ground beef patty, potato, rice, scallion, seaweed

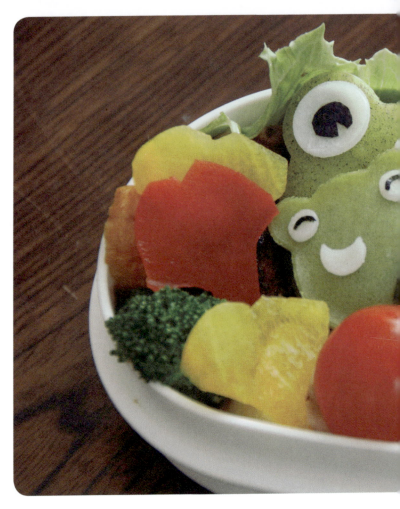

FROG PARTY BY TAKUPAPA

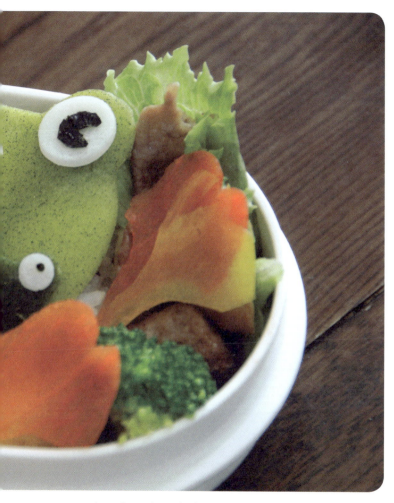

ingredients: beans, broccoli, cheese, corn starch, egg, fish cake, lotus roots, milk, mini meat patty, pork teriyaki, red pepper, rice, seaweed, spinach powder, tomato

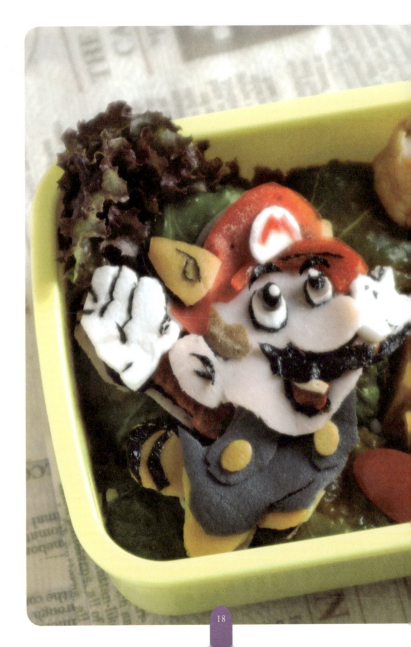

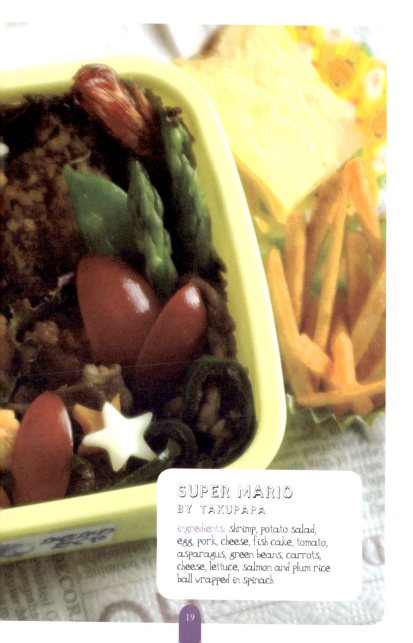

SUPER MARIO
BY TAKUPAPA

ingredients: shrimp, potato salad, egg, pork, cheese, fish cake, tomato, asparagus, green beans, carrots, cheese, lettuce, salmon and plum rice ball wrapped in spinach

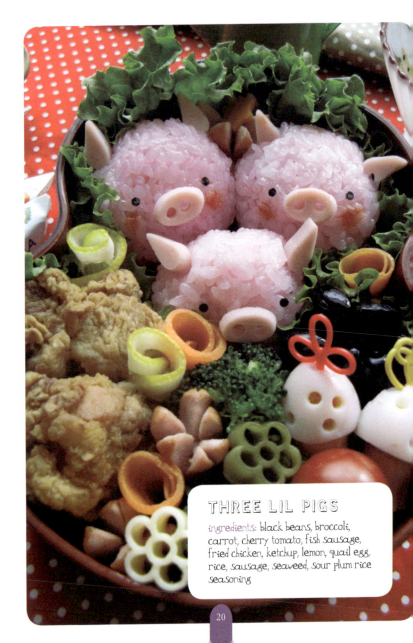

THREE LIL PIGS

ingredients: black beans, broccoli, carrot, cherry tomato, fish sausage, fried chicken, ketchup, lemon, quail egg, rice, sausage, seaweed, sour plum rice seasoning

MAKIKO OGAWA

who do you make charaben for?

I make them for my 5-year-old son, now in kindergarten. He seems delighted that his obento is "different from others." He is also happy that his classmates are looking forward to seeing his charaben everyday.

on average, how much time and money do you spend on making one charaben?

About 30-40 minutes. I don't know the cost.

what is charaben to you?

A communication tool between my child and I and between my child and his classmates. Charaben opens up many unique opportunities for communication and happiness to share with others. Charaben is also a challenge as to how much I can express within the boundaries of an obento.

what is the most challenging thing when making charaben?

I try not to let the character "win," so to speak. I think the most important thing is to stay within the boundary of "obento."

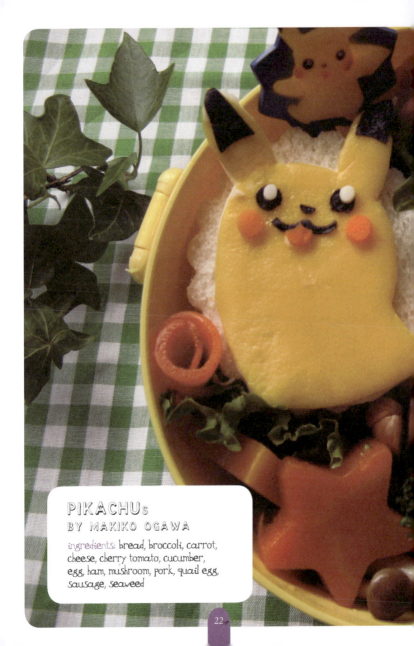

PIKACHUs
BY MAKIKO OGAWA

ingredients: bread, broccoli, carrot, cheese, cherry tomato, cucumber, egg, ham, mushroom, pork, quail egg, sausage, seaweed

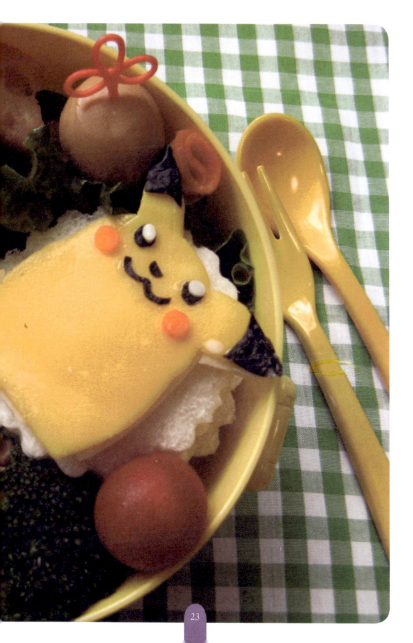

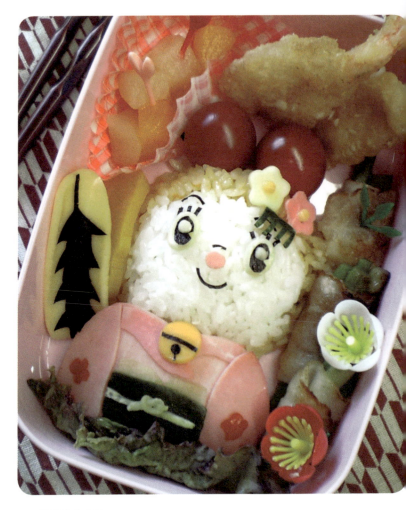

DORAMI BY RISA

ingredients: asparagus, bacon, cheese, cherry tomato, cucumber, fish cake, fried shrimp, peaches, pickled radish, pumpkin seasoning, rice, seaweed, tomato skin

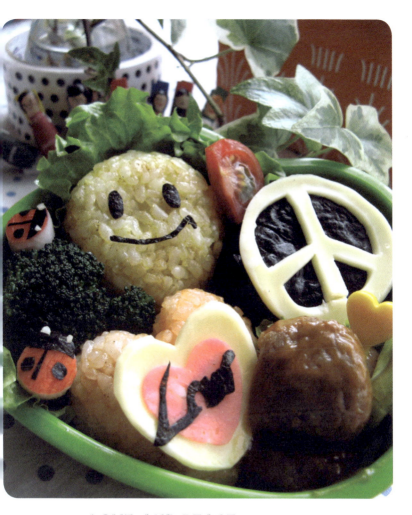

LOVE AND PEACE BY MAKIKO OGAWA

ingredients: broccoli, cheese, cherry tomato, curry powder,
imitation crab meat, ketchup, meatball, rice, seaweed

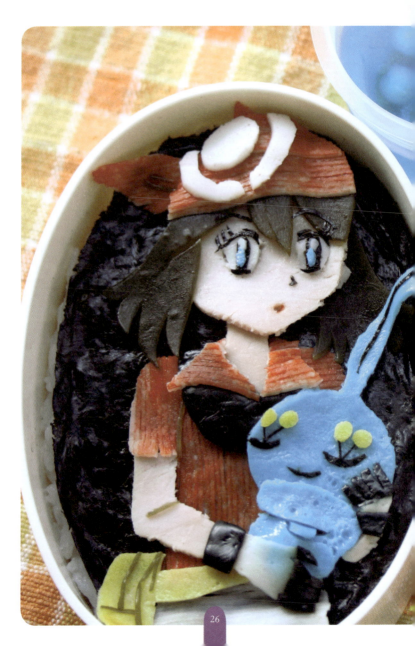

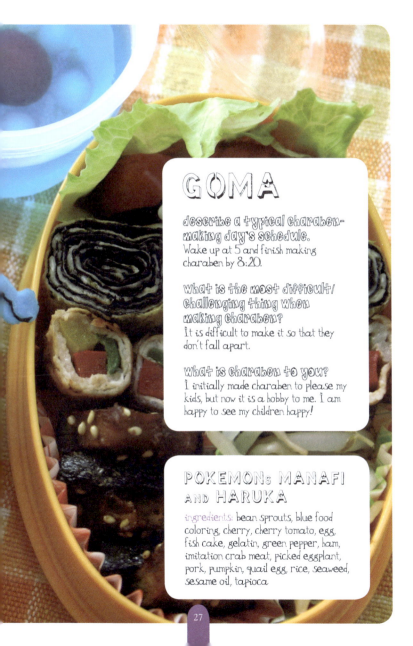

GOMA

describe a typical charaben-making day's schedule.
Wake up at 5 and finish making charaben by 8:20.

what is the most difficult/challenging thing when making charaben?
It is difficult to make it so that they don't fall apart.

what is charaben to you?
I initially made charaben to please my kids, but now it is a hobby to me. I am happy to see my children happy!

POKEMONs MANAFI and HARUKA

ingredients: bean sprouts, blue food coloring, cherry, cherry tomato, egg, fish cake, gelatin, green pepper, ham, imitation crab meat, picked eggplant, pork, pumpkin, quail egg, rice, seaweed, sesame oil, tapioca

27

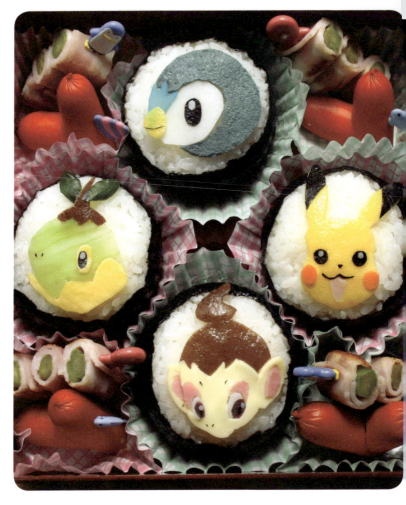

POKEMON BY GOMA

ingredients: asparagus, bacon, carrot, cheese, cocoa powder,
cucumber, egg, fish cake, flour, ham, purple yam potato powder,
rice, sausage, seaweed

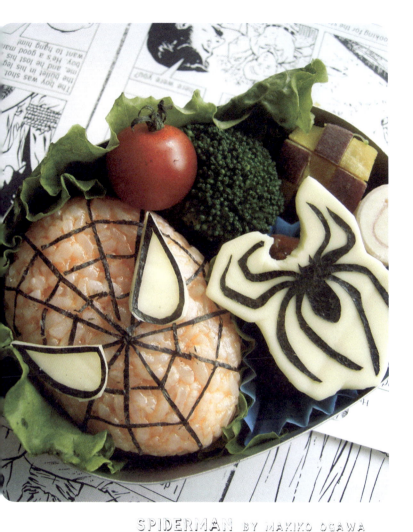

SPIDERMAN BY MAKIKO OGAWA

ingredients: broccoli, cheese, cherry tomato, ham, ketchup, meatball, rice, seaweed, yam potato

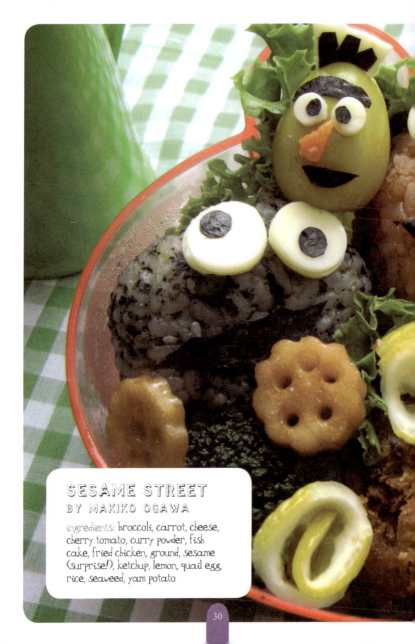

SESAME STREET
BY MAKIKO OGAWA

ingredients: broccoli, carrot, cheese, cherry tomato, curry powder, fish cake, fried chicken, ground, sesame (surprise!), ketchup, lemon, quail egg, rice, seaweed, yam potato

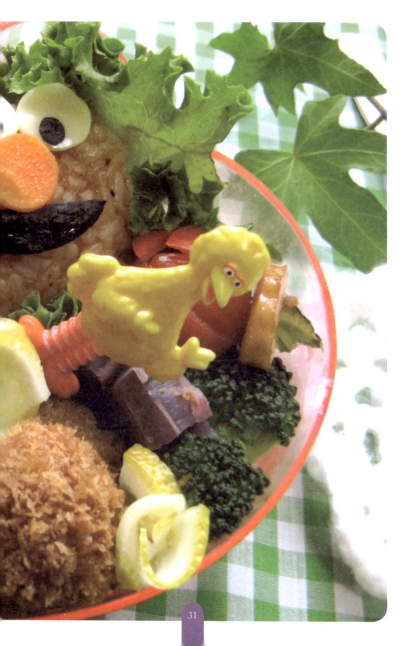

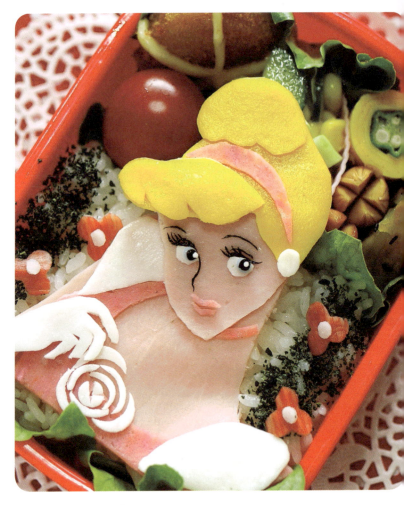

CINDERELLA

ingredients: black sesame, cabbage, cheese, cherry tomato, corn, cucumber, egg, fish, fish cake, green leaf, ground beef, ham, imitation crab meat, okra, eggplant, rice with Japanese basil seasoning, romaine lettuce, sausage, seaweed, yam potato

AKINOICHIGO

since when and why did you start making charaben? how often?

Since October 2005. Twice a week. For my daughter so that she will eat more.

what is the most difficult/challenging thing when making charaben?

To keep a balance between the character and the bento as a whole. I am careful about nutrition and sanitation.

what do you think draws people to charaben?

The moment of excitement you feel when opening the lid. It has a magic power to eliminate all of a child's dislikes.

what is the moment that makes you love/hate charaben?

I love it when my daughter comes home with an empty box. I've also entered a bigger circle of friends through my charaben blog. I never hate making charaben.

what is charaben to you?

The most important thing about charaben is for the child to become happy. It is not as exciting as the TV and other media makes charaben seem to be. All parents want kids to eat nutritionally and healthily without dislikes, and that is the purpose of charaben. Charaben to me is a record of happy memories with my daughter.

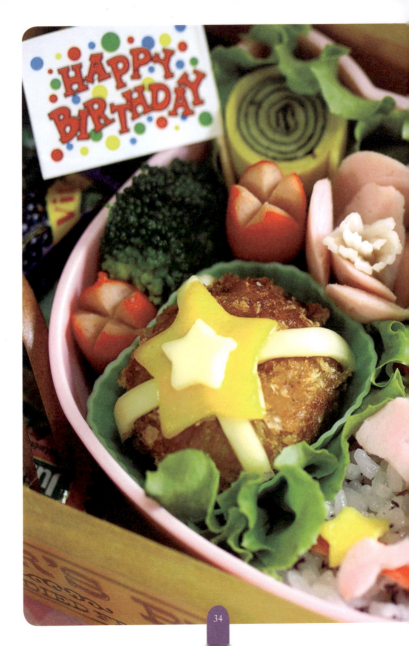

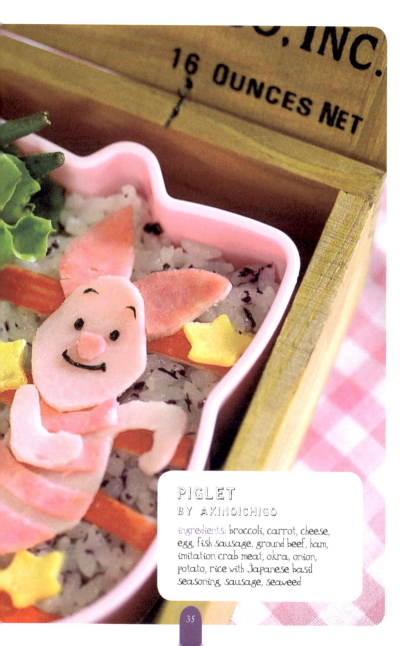

PIGLET
BY AKINOICHIGO

ingredients: broccoli, carrot, cheese, egg, fish sausage, ground beef, ham, imitation crab meat, okra, onion, potato, rice with Japanese basil seasoning, sausage, seaweed

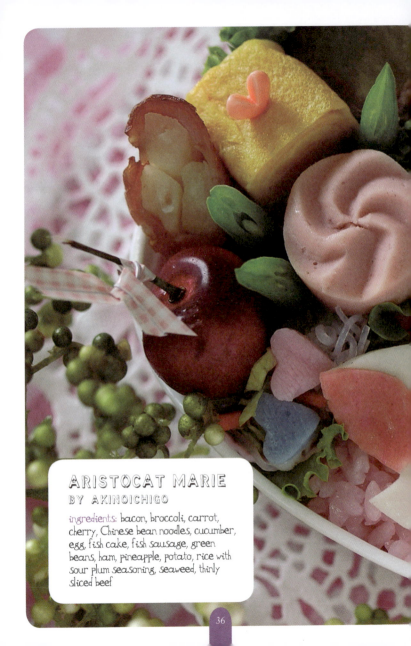

ARISTOCAT MARIE
BY AKINOICHIGO

ingredients: bacon, broccoli, carrot, cherry, Chinese bean noodles, cucumber, egg, fish cake, fish sausage, green beans, ham, pineapple, potato, rice with sour plum seasoning, seaweed, thinly sliced beef

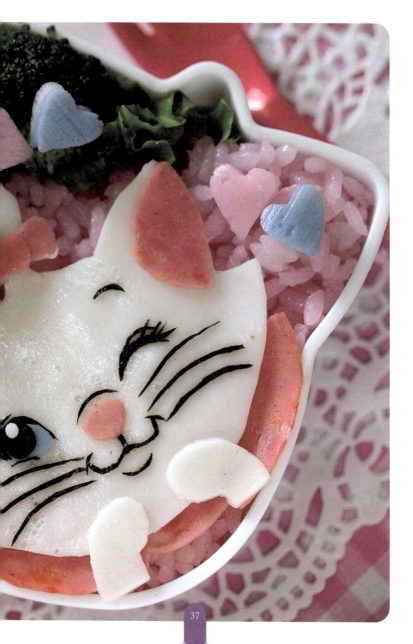

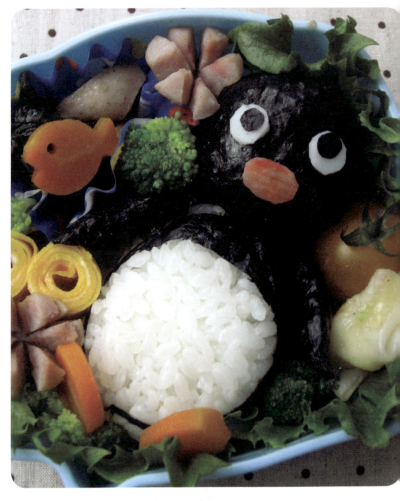

KIRARIN TSUKISHIMA BY MUKU

ingredients: asparagus, bean paste, beans, carrot, egg, eggplant, fish cake, ham, mashed potatoes, pork, potato skin, rice, sardine, seaweed, sesame, spinach, tomato skin

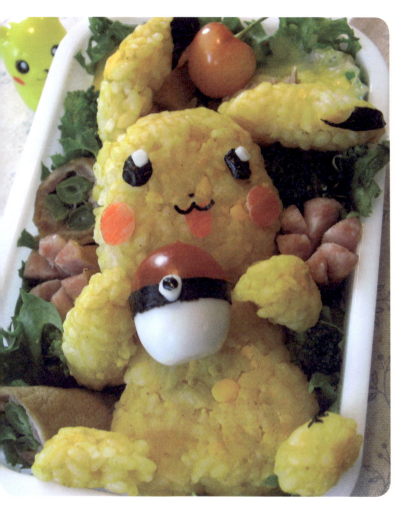

PIKACHU BY MUKU

ingredients: beef, boiled carrots, boiled quail egg, broccoli, cherry, cherry tomato, egg, fish cake, grean beens, imitation crab meat, lettuce, potato salad, rice, sausage, seaweed

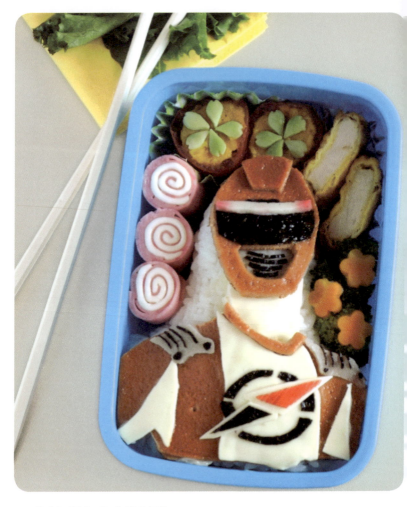

POWER RANGER BY MICHAEL

ingredients: broccoli, cheese, egg, fish cake, ham, imitation crab meat,
ketchup, lettuce, rice, seaweed

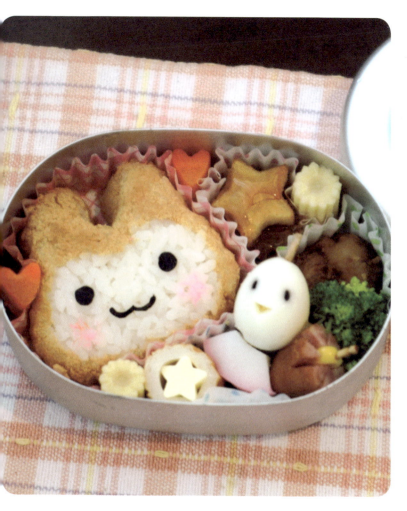

USARU–SAN BUNNY
BY AKIKO WAKABAYASHI

ingredients: boiled carrots, boiled egg, cheese, corn, cucumber,
fish cake, fried chicken, ground soy powder, sausage, seaweed,
sesame, sweet potatoes

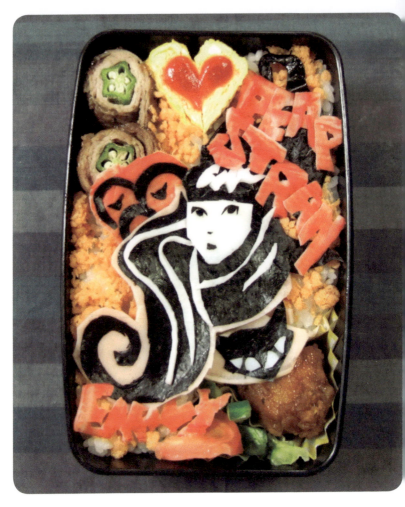

EMILY STRANGE BY KUBO

ingredients: beef, cucumber, egg, fish cake, fried chicken, ham, imitation crab meat, okra, radish, rice, salmon flakes, seaweed, tomato

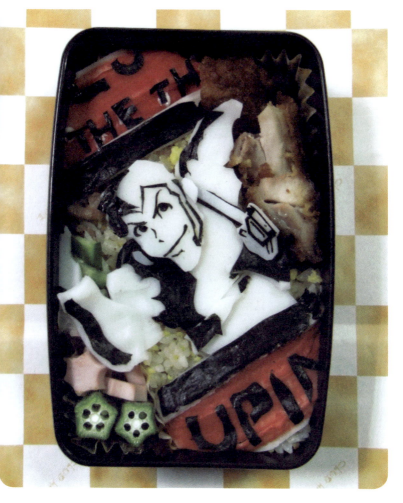

LUPIN THE THIRD BY KUBO

ingredients: bonito, cucumber, fish cake, fried chicken, fried rice, imitation crab meat, okra, sausage, seaweed, tuna

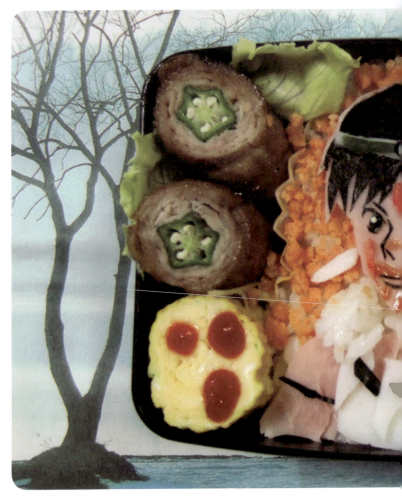

PRINCESS MONONOKE BY KUBO

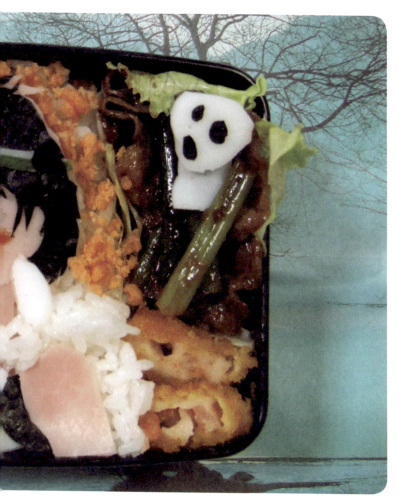

ingredients: beef, cucumber, egg, fish cake, fried shrimp, ham, imitation crab meat, ketchup, mayonnaise, okra, rice, salmon flakes, seaweed

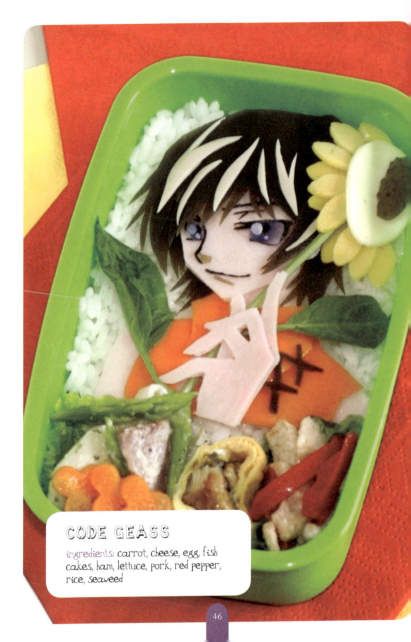

CODE GEASS

ingredients: carrot, cheese, egg, fish cakes, ham, lettuce, pork, red pepper, rice, seaweed

NICO

since when and why did you start making charaben? how often?
Since December 2005. For my child. About once or twice a week.

describe a typical charaben-making day's schedule.
I go shopping the day before and prepare the ingredients. I wake up at 5 and finish making charaben sometime between 7 and 8.

what is the moment that makes you love/hate charaben?
Love: Now my son eats more. Hate: Now my son wants me to make one everyday.

what is charaben to you?
A pleasure for both my son and I. It is a way for me to relieve my daily stresses.

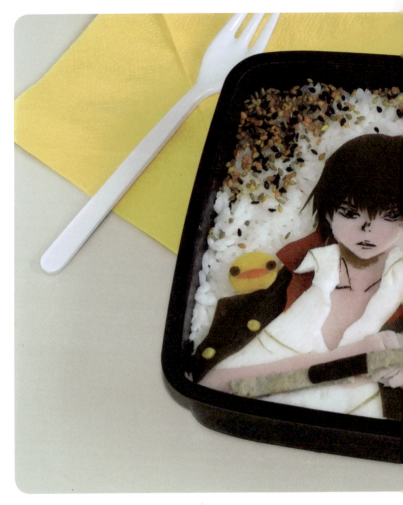

HOME TUTOR HITMAN REBORN! BY NICO

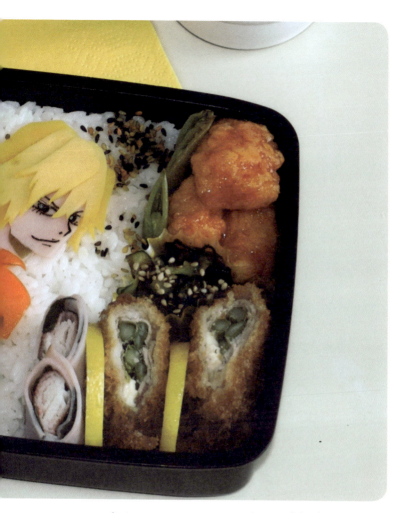

ingredients: asparagus, carrot, cucumber, egg, fish cakes, green beans, ham, imitation crab meat, lemon, pork, red pepper, rice, seaweed, sesame

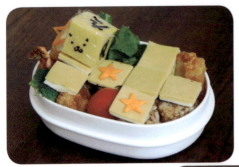

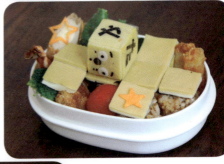

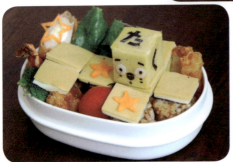

POTEJIN

ingredients: beans, broccoli, cheese, corn starch, egg, fish cake, lotus roots, milk, mini meat patty, pork teriyaki, red pepper, rice, seaweed, spinach powder, tomato

TETSUYA KAKIKAWA AKA TAKUPAPA

since when and why did you start making charaben? how often?

Since April 2006. My wife was hospitalized for some time, so I started making obento in place of her. About four times a week.

who do you make charaben for? how is his/her response?

I make them for my son in kindergarten now. He used to love anything I make, but now he is happy only when I make a character that he likes. He seems to have had enough.

describe a typical charaben-making day's schedule.

The day before I come home at 12AM and spend 1-3 hours preparing the character. I wake up at 8 and make the obento in 30 minutes. I photoshoot for 5 minutes and give the charaben to my son who leaves home at 8:50.

what is charaben to you?

Charaben is a collection of precious times I spent with my son. Each and every charaben has an episode, and I hope they will become good memories when he grows up.

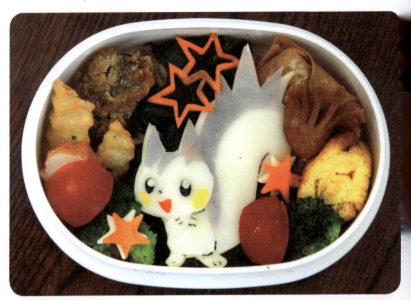

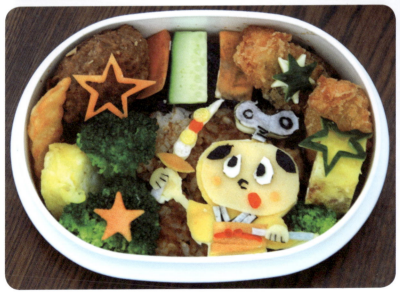

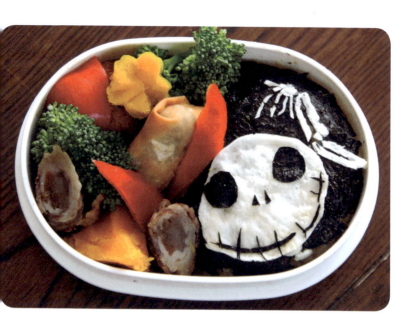

POKEMONs PACHIRISU BY TAKUPAPA

ingredients: bonito flakes, broccoli, carrot, cheese, egg, fish
cake, fried shrimp, mini spring rolls, potato, rice, sausage,
tomato

ZENMAI SAMURAI BY TAKUPAPA

ingredients: bonito flakes, broccoli, carrots, cucumber, egg,
fried cheese and fish cakes, fried shrimp, potato, rice,
seaweed

JACK SKELLINGTON BY TAKUPAPA

ingredients: beef roll, broccoli, curry rice, fried seafood ball,
mini spring rolls, pumpkin, red pepper, seaweed

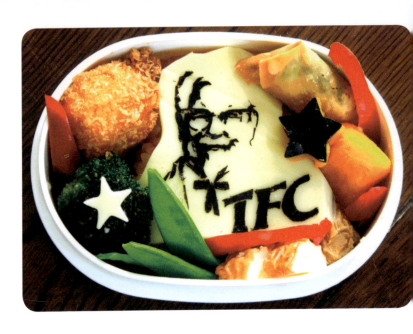

TAKKUN FRIED CHICKEN BY TAKUPAPA

ingredients: broccoli, cheese, cheese, fish cakes, fried seafood ball, green beans, ketchup, mini spring rolls, pumpkin, red pepper, rice, seaweed

POKEMONs SONANSU BY TAKUPAPA

ingredients: boiled quail egg, broccoli, carrot, cheese, cherry tomato, egg, fish cake, fried beef and cheese, fried cheese and fish cakes, fried shrimp, mini spring rolls, rice ball with salmon and Japanese basil, sausage, spinach

ROCKETSHIP BY TAKUPAPA

ingredients: broccoli, cheese, cherry tomato, fish cakes, fried chicken, fried curry ball, fried noodles, mini beef patty, mini spring roll

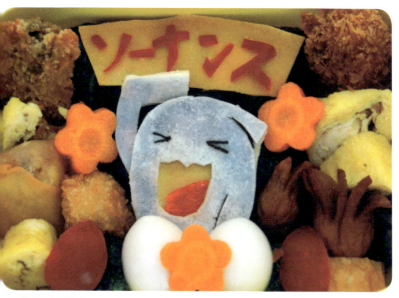

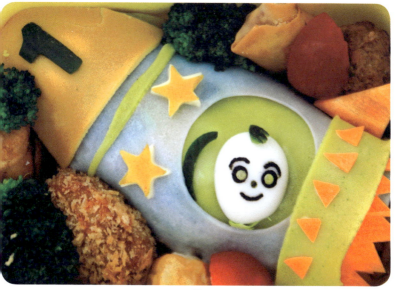

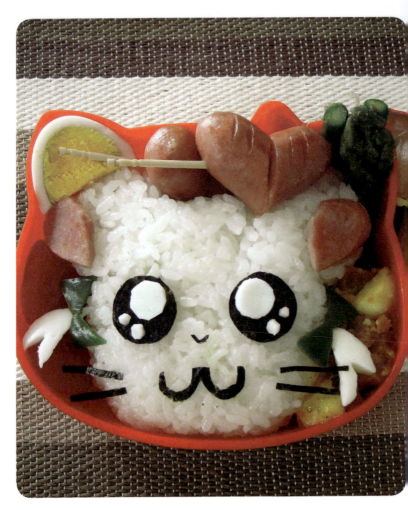

PIE-EYED KITTEN BY FUMIE IGARASHI

ingredients: asparagus, curry powder, egg, fish cake, green pepper, sausage, seaweed, tomato

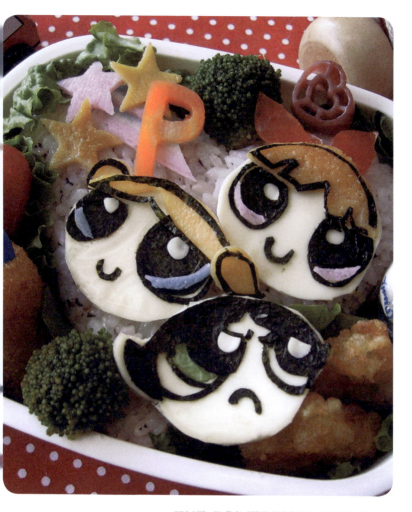

THE POWERPUFF GIRLS
BY MAKIKO OGAWA

ingredients: broccoli, carrot, cheese, cherry tomato, egg, fish cake, fried croquette, Japanese basil, lettuce, pasta, potato hash, rice, seaweed, tomato

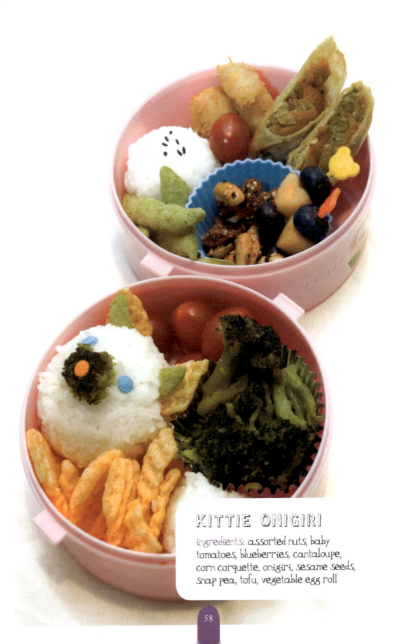

KITTIE ONIGIRI

ingredients: assorted nuts, baby tomatoes, blueberries, cantaloupe, corn corquette, onigiri, sesame seeds, snap pea, tofu, vegetable egg roll

MARI BAKER NATAKIYA

what got you into designing bentos?

My family and I are fans of anime. I decided to find more information about this phenomenon and was amazed at the variety of creative ways to prepare food.

The idea of a fun, easily portable meal for my daughter to take along on outings with friends that originally caught my interest. Being vegetarians, it is sometimes difficult to fit in at grilling parties or sleep-overs without making the host do extra work. I was looking for something that would make her feel special and excited rather than left out and embarrassed, and eliminate the need for extra effort by others to accommodate our meal preferences. Bentos are so perfect a solution that I was delighted and immediately jumped right in.

what connection do you feel you have, if any, to the art of bento design?

Asian art and culture have always fascinated me. For several years I have been studying Asian textiles and practicing the Japanese braiding art of Kumihimo. Branching out into bento lunches seems like a natural progression of my interest.

The bento making community on Flickr, LiveJournal, Tribe and blogs, etc. is overwhelmingly supportive and it is really amazing how bentos and food art have drawn together people from everywhere!

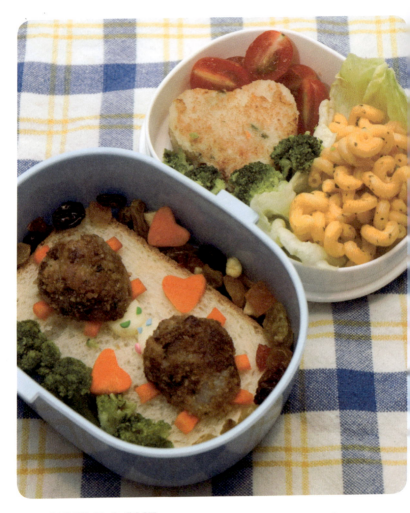

TURTLE LOVE BY MARI BAKER NATAKIYA

ingredients: baby tomato, broccoli, macaroni and cheese, potato, vegetable pancake

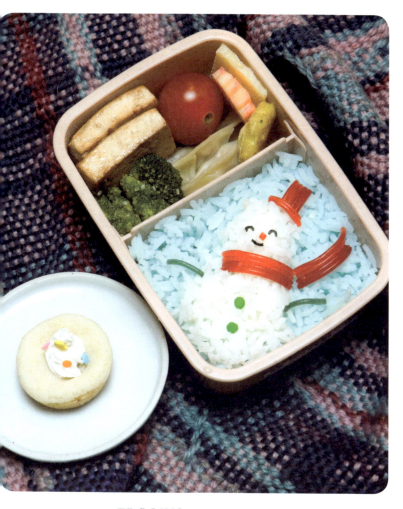

FROSTY BY MARI BAKER NATAKIYA

ingredients: food coloring, Kellogg Fruit Streamers, nori, rice, sugardots

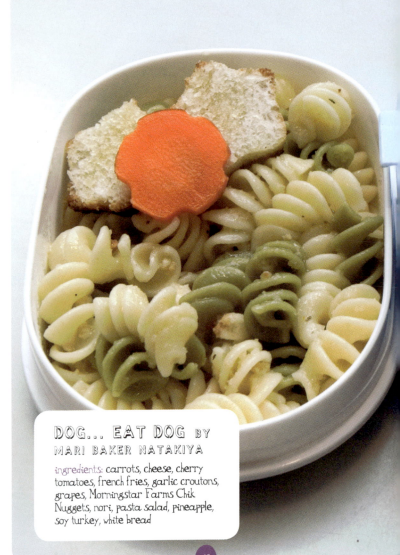

DOG... EAT DOG BY MARI BAKER NATAKIYA

ingredients: carrots, cheese, cherry tomatoes, french fries, garlic croutons, grapes, Morningstar Farms Chik Nuggets, nori, pasta salad, pineapple, soy turkey, white bread

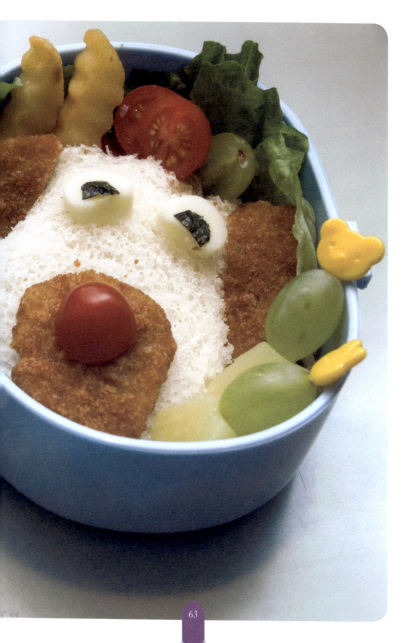

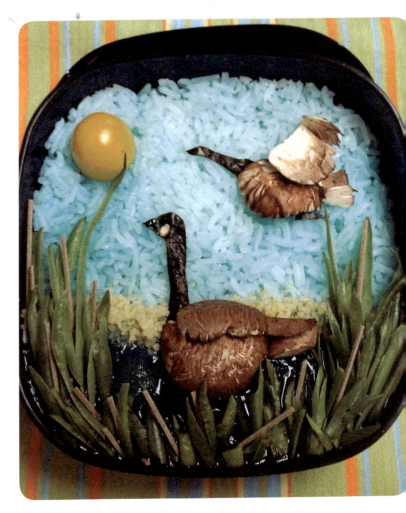

GOOSE HUNT BY AMORETTE DYE

ingredients: basmati rice, couscous, green beans, nori, pear sauce, portabella mushrooms, sesame seeds, yam soba noodles, yellow pear cherry tomato

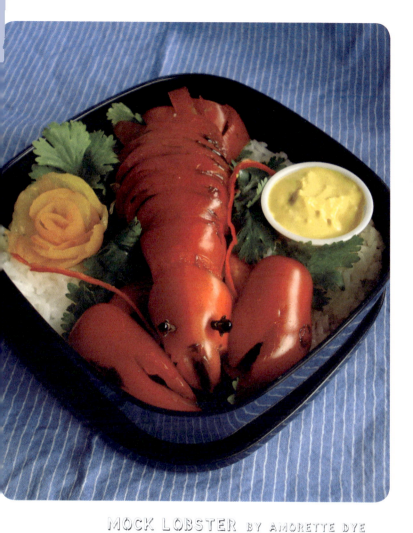

MOCK LOBSTER BY AMORETTE DYE

ingredients: cayenne pepper, cloves, cilantro greens, egg, jasmine
rice, mayonnaise, mustard, roma tomatoes, yellow tomato

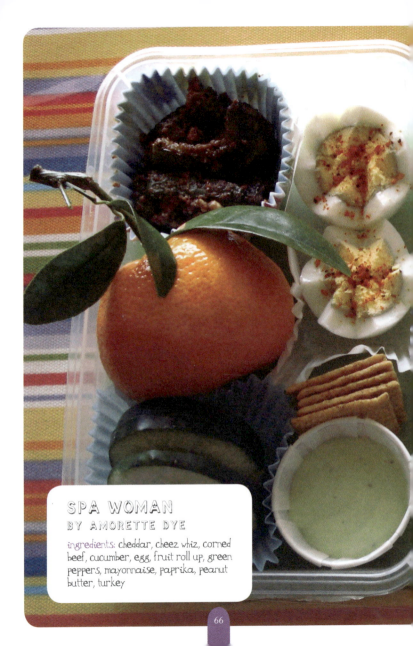

SPA WOMAN
BY AMORETTE DYE

ingredients: cheddar, cheez whiz, corned
beef, cucumber, egg, fruit roll up, green
peppers, mayonnaise, paprika, peanut
butter, turkey

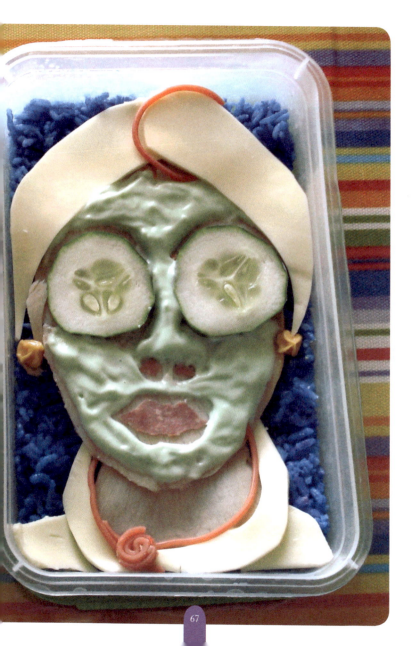

SAYURI KUBO

since when and why did you start making charaben? how often?

Since November 2005. It all started when my parents left for a few weeks to go on a trip abroad. In my mother's absence I had to make obento's for my younger brother and sister. I loved making them, so I just kept making them even after my parents returned. I started making charaben when I got bored with regular obento. I make charaben almost everyday.

who do you make charaben for? how is his/her response?

I make them for my younger sister. No response from her at all! She is a 20-year-old.

how do you choose which character to make? which character is your favorite?

Instinct and gut feelings! My favorite is the Harry Potter series.

describe a typical charaben-making day's schedule.

My mother does all grocery shopping at home. I start making charaben at 9AM and finish by 10:30-11:00. My sister goes to work at 2:00PM.

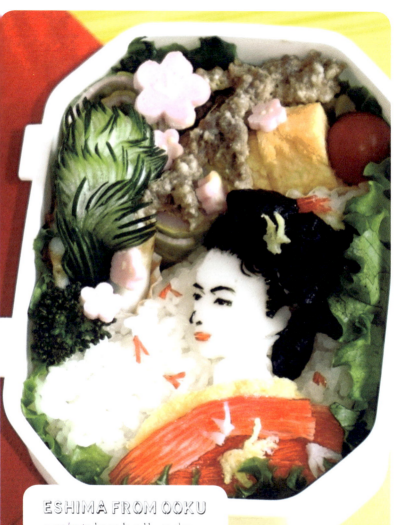

ESHIMA FROM OOKU

ingredients: broccoli, cabbage, cherry tomato, eggs, fish cakes, fish sausage, green beans, ham, imitation crab meat, meatballs, seaweed

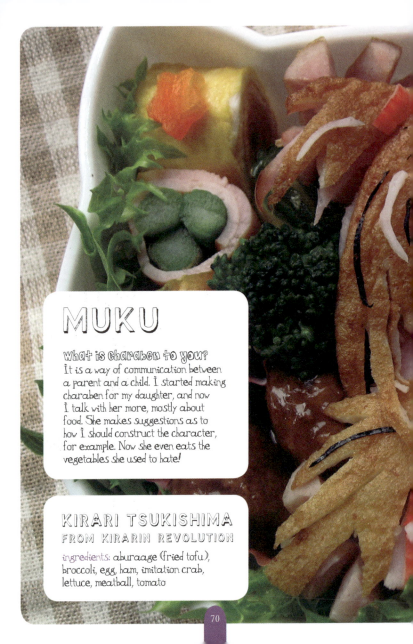

MUKU

what is charaben to you?

It is a way of communication between a parent and a child. I started making charaben for my daughter, and now I talk with her more, mostly about food. She makes suggestions as to how I should construct the character, for example. Now she even eats the vegetables she used to hate!

KIRARI TSUKISHIMA
FROM KIRARIN REVOLUTION

ingredients: aburaage (fried tofu), broccoli, egg, ham, imitation crab, lettuce, meatball, tomato

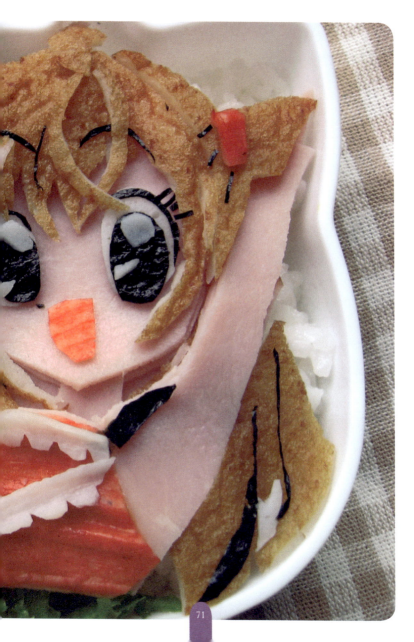

MAKING YOUR OWN CHARACTER BENTO

The logistics behind the actual preparation and sculpting of your very own character bento is a mind-numbing exercise in patience. Cute as they can be and no matter how simple a *charaben* might look, the vast amounts of time and practice put into perfecting these transitory pleasures is on par with the skill-sets of a master baker, chef, or patissier. Without a demented-devotion or at least a few rounds of practice, nobody can expect to assemble a batch of foodstuffs to resemble something as complex as the examples in this book. As these two "how-to's" show, what comes easiest is the dyeing and molding of rice; even the trimming of cheese is a breeze (when you've drawn out the shapes beforehand, of course). What real *charaben* sculptors seem to understand most is not just the choices of foods and colors in the bento box, but how each element interacts with the next – something I found lacking in my own bento practices. With food presentation such an important stage in the culinary arts, each of these *charaben* masters seems to have found a real directorial eye and magically applied it to the preparation of their food.

The first real step in making a *charaben* is choosing a particular likeness or scene to create. Is your interest in landscapes, still-life, or would you like to jump right into a familiar Japanese cartoon character like Pikachu, Goku, or Hello Kitty? Once you have it down in your head how you'd like your *charaben* to look, the next step is to choose the ingredients. How could you best represent your image? Think colors, textures, and just as important: nutrition. It's all about the imagination. If rocks are something you need to represent, you could go with nuts, seeds, or appropriately sized meatballs. If you need thin lines of detail, a sharp blade to some seaweed will do the trick. Noodles for hair, broccoli for trees… you get the picture.

When you finally sit down to decide on your own unique bento design, the possibilities that might have once seemed limitless can quickly turn into frustration. Early advice: practice in the evening with a friend, after a meal or a glass of wine, and remember to keep things simple and fun. Since most *charaben* are made for children, I only had to look into my own past to come up with idea number one: the orange ghost character (named "Clyde" in the US) from the biggest video game of all time: Pac-Man.

THE PAC-MAN GHOST

1. *Onigiri* (formed rice). In order for our specter to stand out, a basic chick pea *onigiri* is molded into a rough rectangular shape.

2. Cheddar cheese, sliced into the shape of our ghost.

3. Swiss cheese, with sliced *nori* eyeballs.

4. Blackberry-stuffed tomato "pellets." Like in the game, Pac-Man is after his power pellets, and it's the ghost who has to stop him.

5. *Hijiki* seaweed.

6. *Kinpira-gobo* (simmered burdock root).

7. *Edamame* (boiled soybeans).

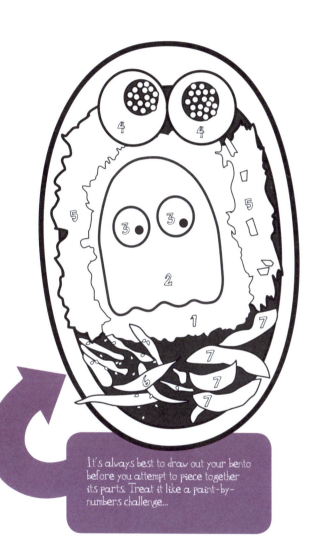

It's always best to draw out your bento before you attempt to piece together its parts. Treat it like a paint-by-numbers challenge...

A STARRY NIGHT

For my follow-up bento design, I thought I might utilize one of the few rice molds picked up during my stay in Tokyo – the star. If you don't have access to a Japanese specialty shop, just make sure your rice is fresh and sticky enough to form by hand.

1 A simple bed of white rice (turned blue with food coloring) to create the sky backdrop.

2 For the large stars, cut the shapes out from cheese. Molds could also be used, each stuffed with potato or tofu and lightly fried to retain its shape.

3 Create the ground with sesame seeds, seaweed salad, and celery.

4 Slice unskinned, cooked potatoes to form mountain ranges. Accentuate the ground around them with bits of cheese, onion, or carrot, to take the form of smaller rocks.

5 Vegetable (or meat) patty for the moon.

6 For accents in the sky, strips of *nori* (dry edible seaweed) are easily sliced for star trails.

Never feel hesitant to make your own substitutions. If seaweed for grass isn't your thing, you can try other vegetables such as spinach, broccoli, or even sliced lettuce.

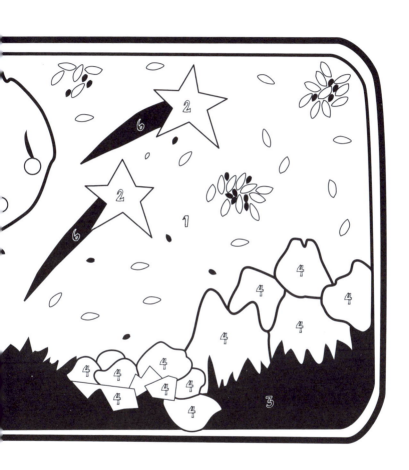

If your first few attempts fall flat, fret not: it only goes to show the degree of skill involved in these pint-sized delectables. To a Western mind whose idea of a home-packaged meal being a sandwich and chips, I vouch for every person who has ever made a *charaben* when I say, "I feel your frustrations, I've been there."

Mari Baker Natakiya (pages 58-63) tries to never let her frustrations get the better of her, for bentos lose their charm once they begin to feel like extra work. To her and others like her, *charaben* is a skillset that can only be cultivated over time: no different than any other hobby, video game, or craft. An important element for her is the amount of food variety that it's brought into the household. As she told me: "My husband fell in love with lychees when I put them in our bentos for the first time, something that he would never have thought to try otherwise."

This reminds me: I was traveling back from one of my Tokyo bento excersions when my companion dug into my satchel and pulled out a charaben made for me, in the shape of panda-suit-wearing Hello Kitty. Who has ever eaten such a thing? I hadn't really paid it close attention until then, but seeing it in my friend's hands as she held it out like a chalise offered to the gods, I felt a curious wave of child-like awe, when you can't tell whether you're standing on your head or your heels. That feeling was immediately broken, however, when my friend pulled a small fork out from her purse and dug it straight into the face (between the eyes, no less!) of my little Hello Kitty. "I was really starving," she muttered to me, after downing at least half of the rice body. "I couldn't resist, just look at it! We Japanese excel at more than just video games." And with that, I conceded. But not before getting my own taste.